DesignOriginals

Creative Coloring
Botanicals

Valentina Harper

DESIGN ORIGINALS
an Imprint of Fox Chapel Publishing
www.d-originals.com

Basic Color Ideas

In order to truly enjoy this coloring book, you must remember that there is no wrong way—or right way—to paint or use color. My drawings are created precisely so that you can enjoy the process no matter what method you choose to use to color them!

The most important thing to keep in mind is that each illustration was made to be enjoyed as you are coloring, to give you a period of relaxation and fun at the same time. Each picture is filled with details and forms that you can choose to color in many different ways. I value each person's individual creative process, so I want you to play and have fun with all of your favorite color combinations.

As you color, you can look at each illustration as a whole, or you can color each part as a separate piece that, when brought together, makes the image complete. That is why it is up to you to choose your own process, take your time, and, above all, enjoy your own way of doing things.

To the right are a few examples of ways that you can color each drawing.

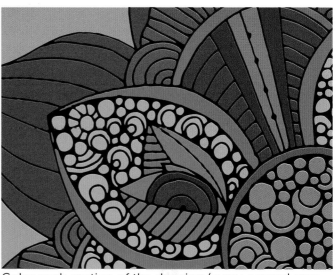

Color each section of the drawing (every general area, not every tiny shape) in one single color.

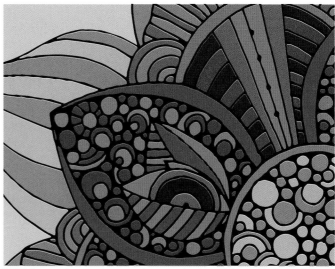

Within each section, color each detail (small shape) in alternating colors.

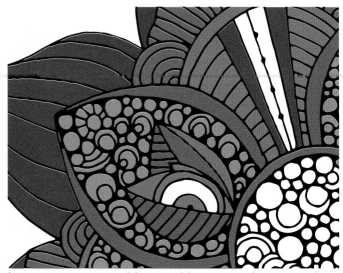

Leave some areas white to add a sense of space and lightness to the illustration.

Basic Color Tips

As an artist, I love to mix techniques, colors, and different mediums when it comes time to add color to my works of art. And when it comes to colors, the brighter the better! I feel that with color, illustrations take on a life of their own.

Remember: when it comes to painting and coloring, there are no rules. The most fun part is to play with color, relax, and enjoy the process and the beautiful finished result.

Feel free to mix and match colors and tones. Work your way from primary colors to secondary colors to tertiary colors, combining different tones to create all kinds of different effects. If you aren't familiar with color theory, below is a quick, easy guide to the basic colors and combinations you will be able to create.

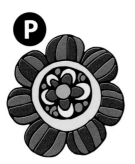

Primary colors: These are the colors that cannot be obtained by mixing any other colors; they are yellow, blue, and red.

Secondary colors: These colors are obtained by mixing two primary colors in equal parts; they are green, purple, and orange.

Tertiary colors: These colors are obtained by mixing one primary color and one secondary color.

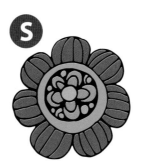
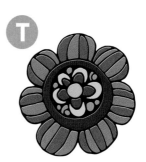

Don't be afraid of mixing colors and creating your own palettes. Play with colors—the possibilities are endless!

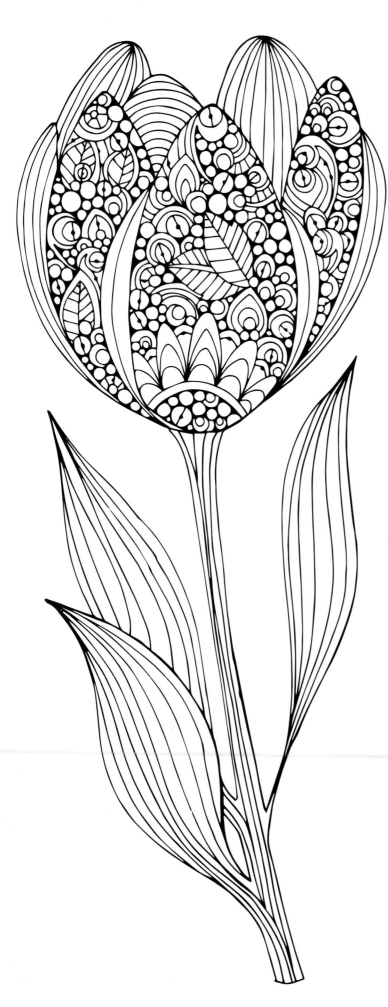

Color Inspiration

On the following eight pages, you'll see fully colored samples of my illustrations in this book, as interpreted by one talented artist and author, Marie Browning. I was delighted to invite Marie to color my work, and she used many different mediums to do so, all listed below each image. Take a look at how Marie decided to color the doodles, and find some inspiration for your own coloring! After the colored samples, the thirty delightful drawings just waiting for your color begin. Remember the tips I showed you earlier, think of the color inspiration you've seen, and choose your favorite medium to get started, whether it's pencil, marker, watercolor, or something else. Your time to color begins now, and only ends when you run out of pages! Have fun!

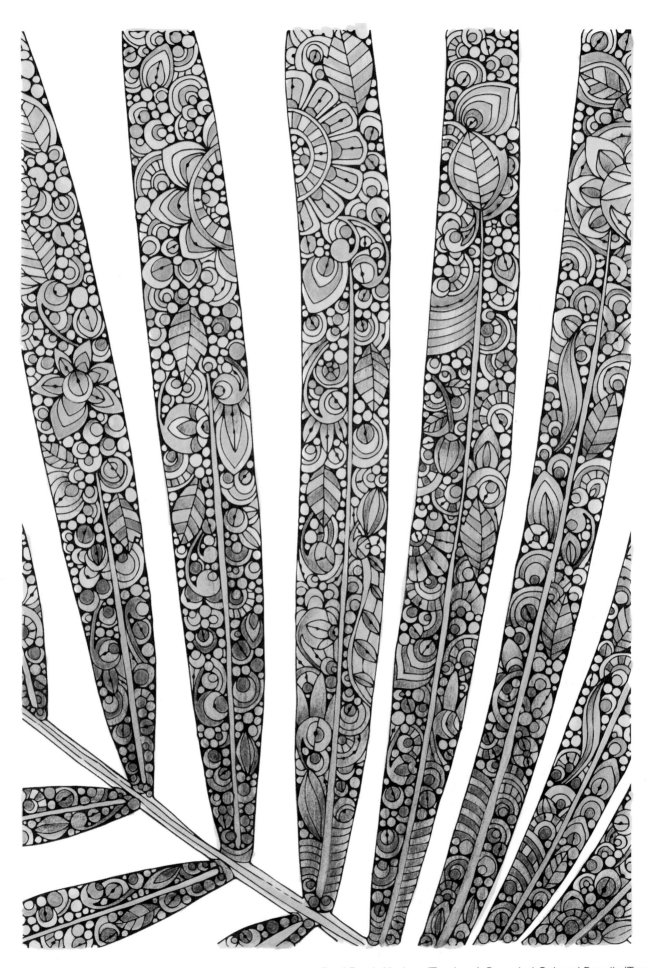

Dual Brush Markers (Tombow), Recycled Colored Pencils (Tombow).
Monochromatic tones. Color by Marie Browning.

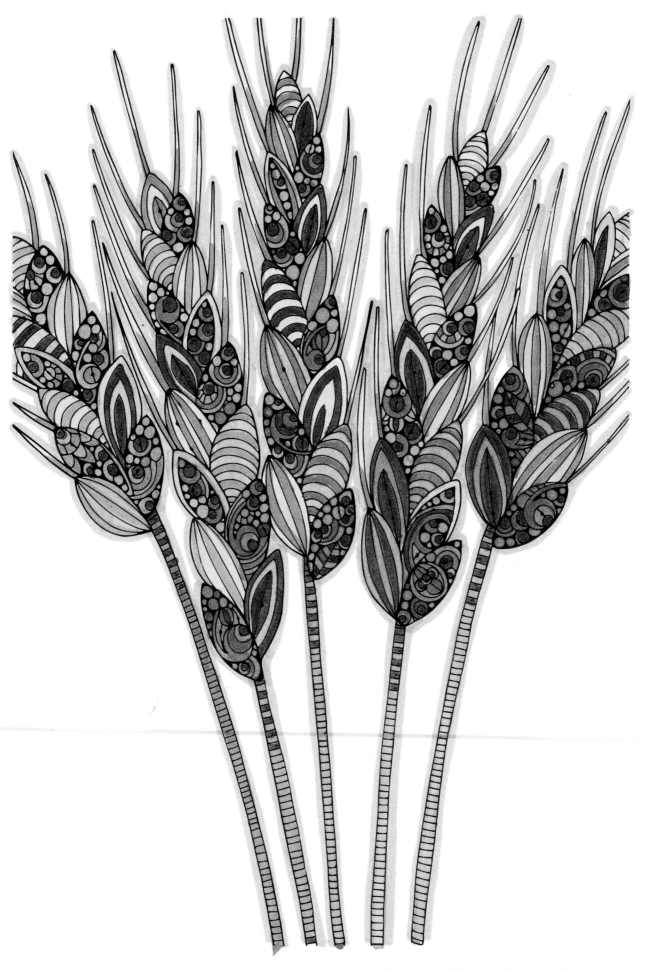

Watercolors (Winsor & Newton). Monochromatic tones.
Color by Marie Browning.

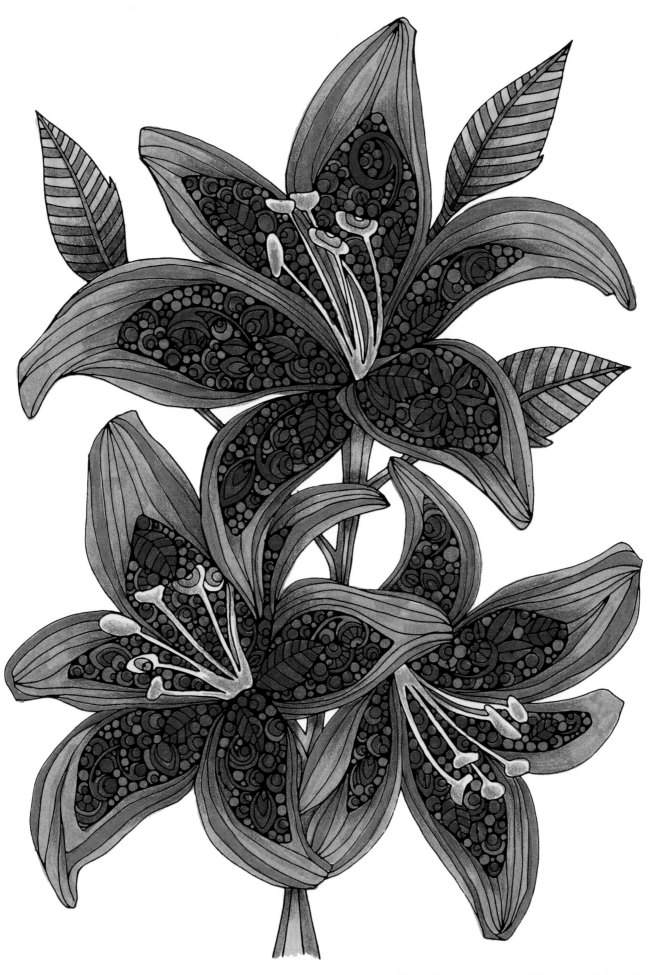

Dual Brush Markers (Tombow), Recycled Colored Pencils
(Tombow). Warm tones. Color by Marie Browning.

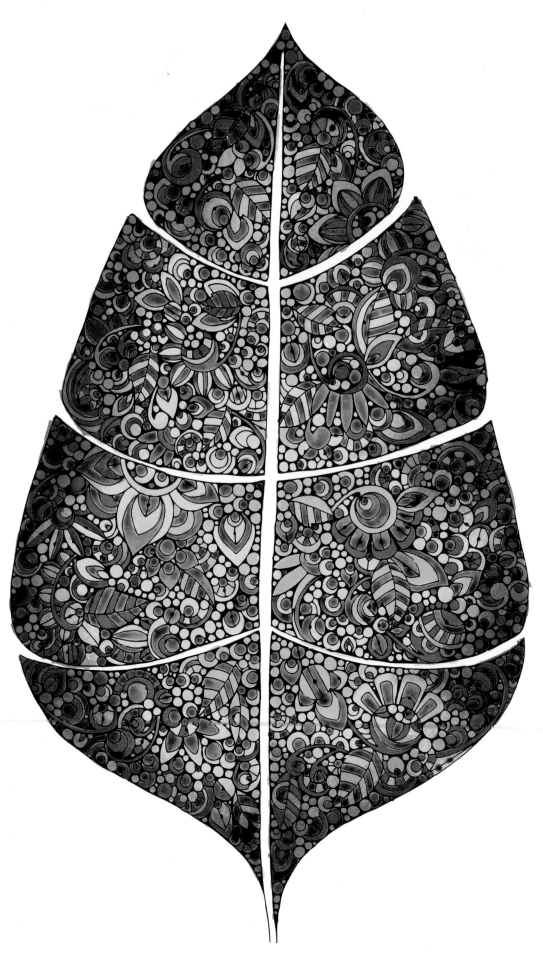

Dual Brush Markers (Tombow), Gel Pens (Sakura).
Complementary tones. Color by Marie Browning.

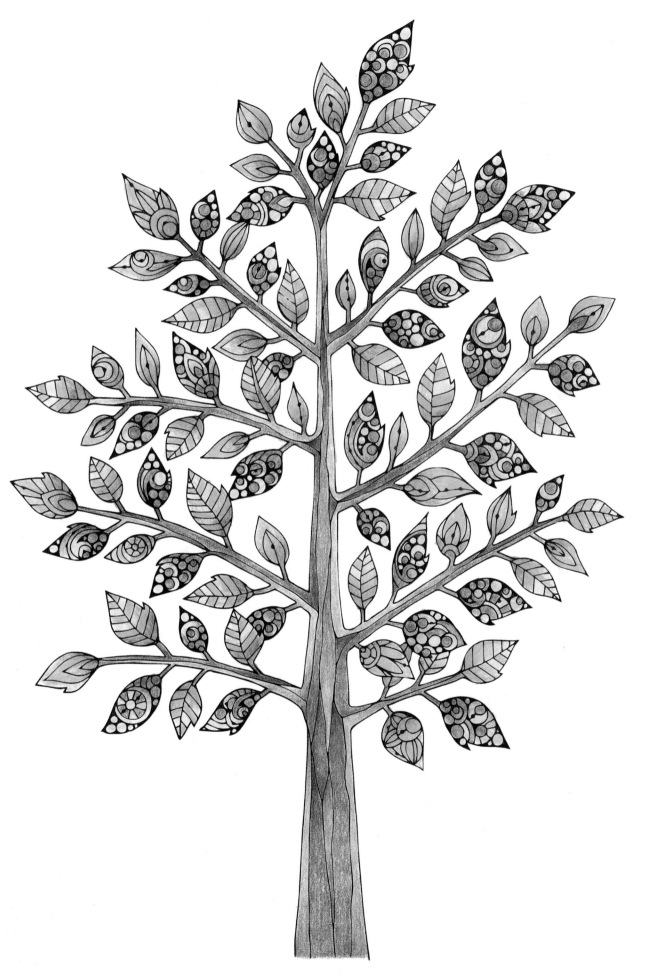

Irojiten Colored Pencils (Tombow). Designer tones.
Color by Marie Browning.

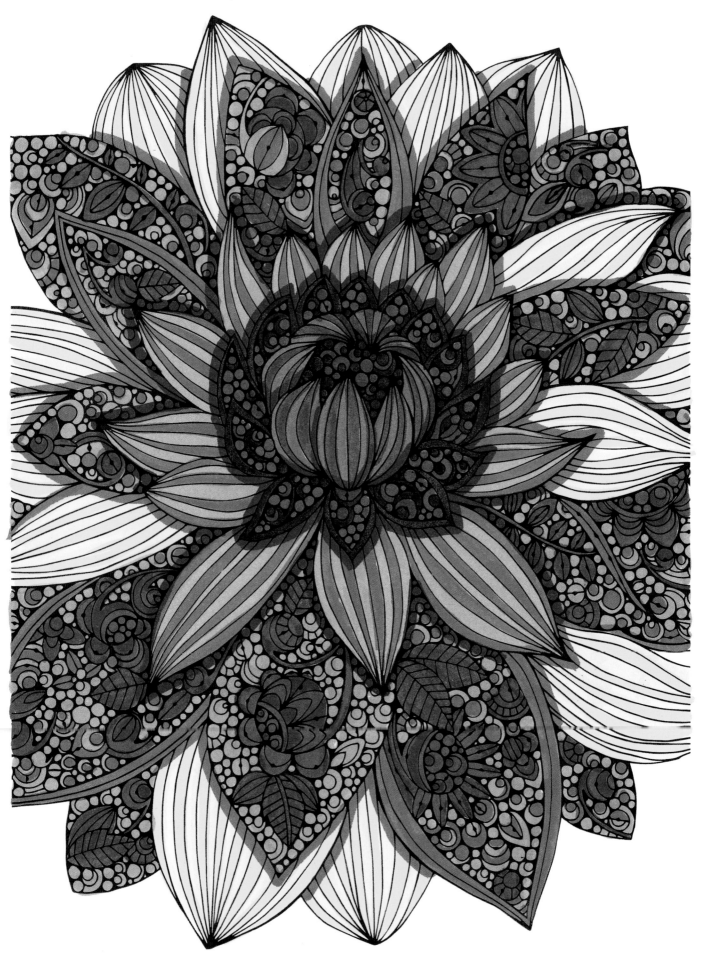

Dual Brush Markers (Tombow). Analogous warm tones.
Color by Marie Browning.

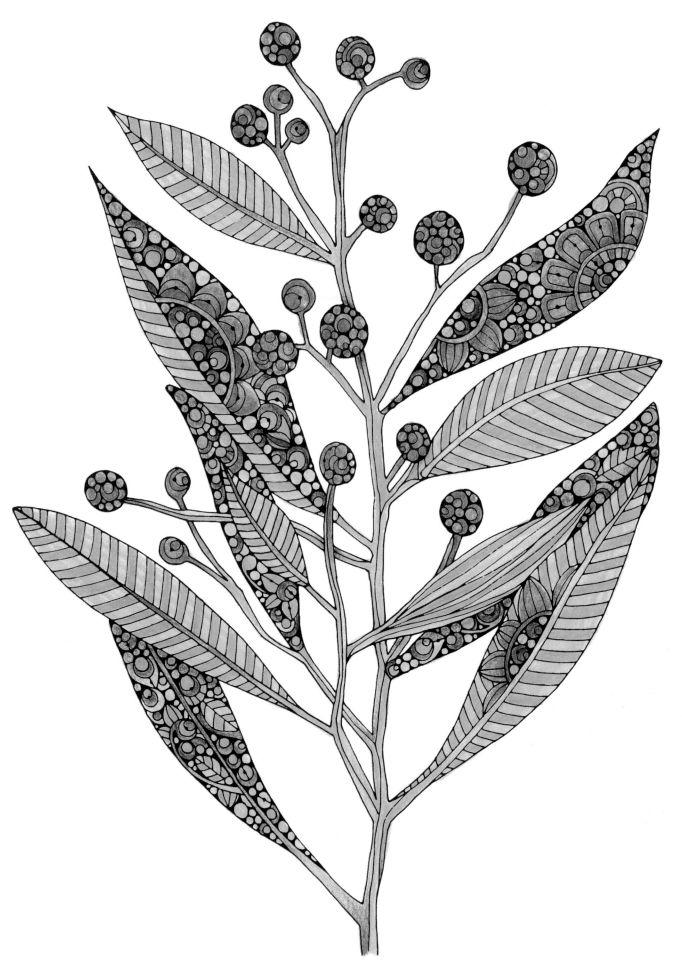

Irojiten Colored Pencils (Tombow). Bright tones.
Color by Marie Browning.

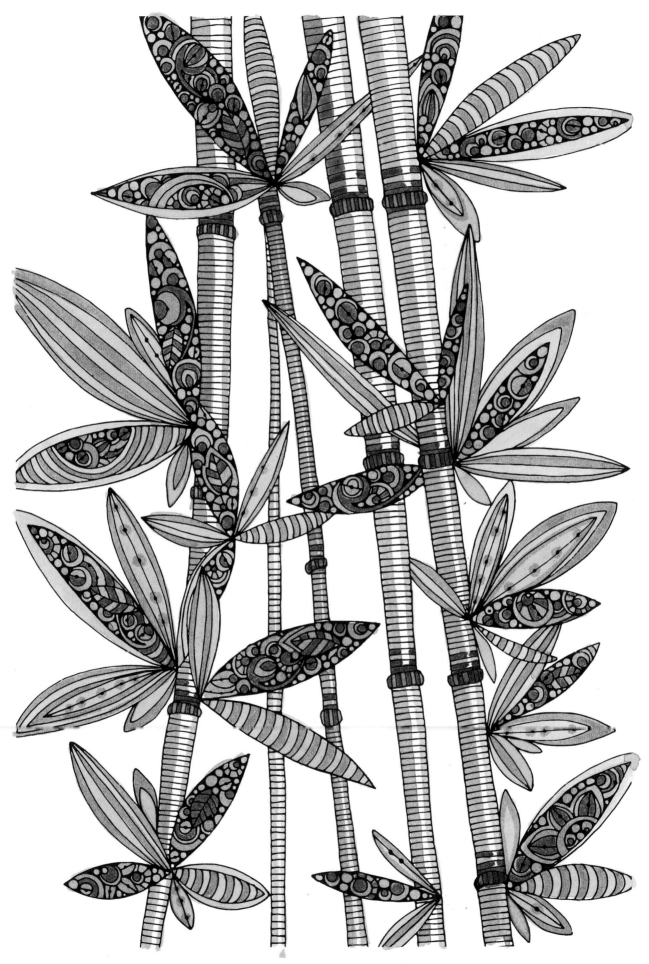

Watercolors (Winsor & Newton). Natural tones.
Color by Marie Browning.

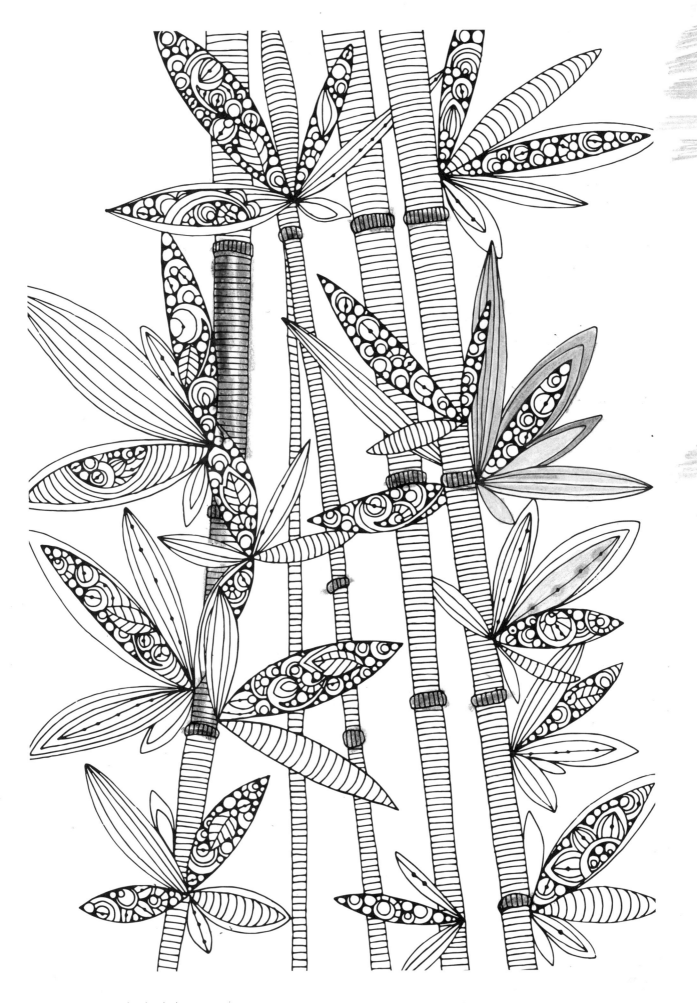

Some old-fashioned things like fresh air
and sunshine are hard to beat.

—Laura Ingalls Wilder

Lydia

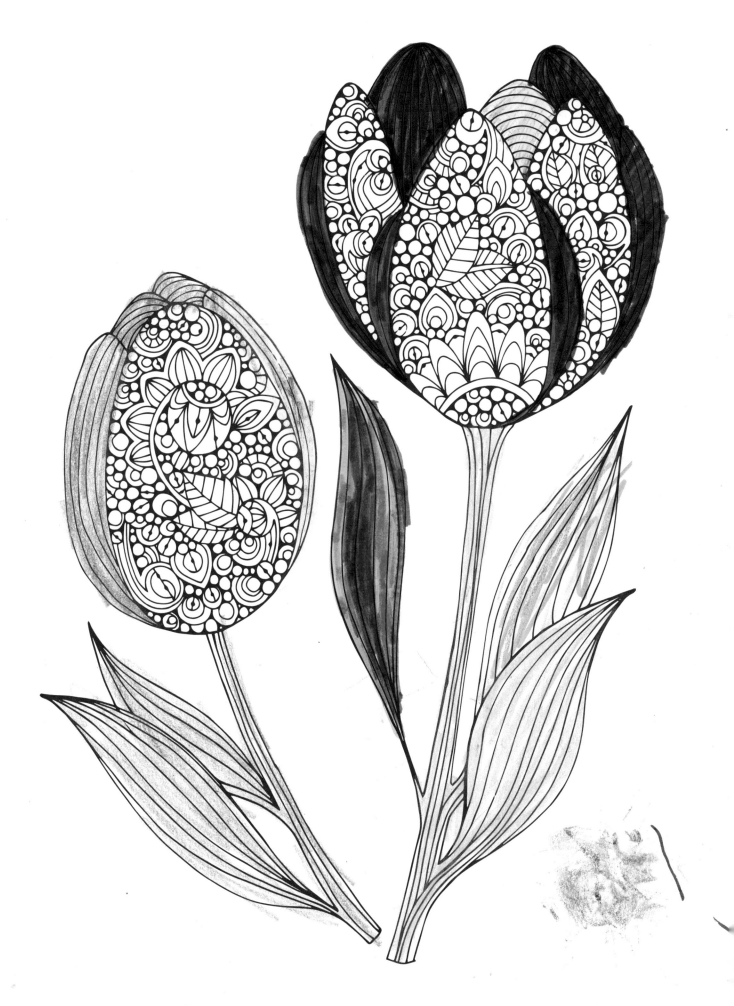

For in the true nature of things, if we rightly
consider, every green tree is far more glorious
than if it were made of gold and silver.

—Martin Luther

Aegina

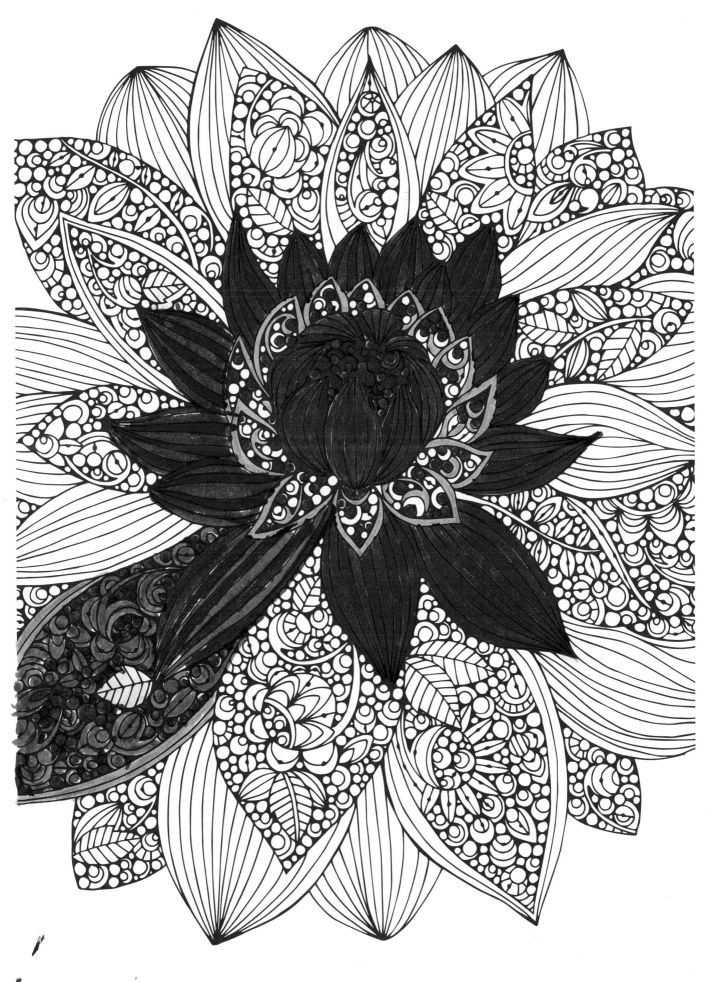

© Valentina Harper, www.valentinadesign.com

Every flower is a soul blossoming in nature.

—Gérard de Nerval

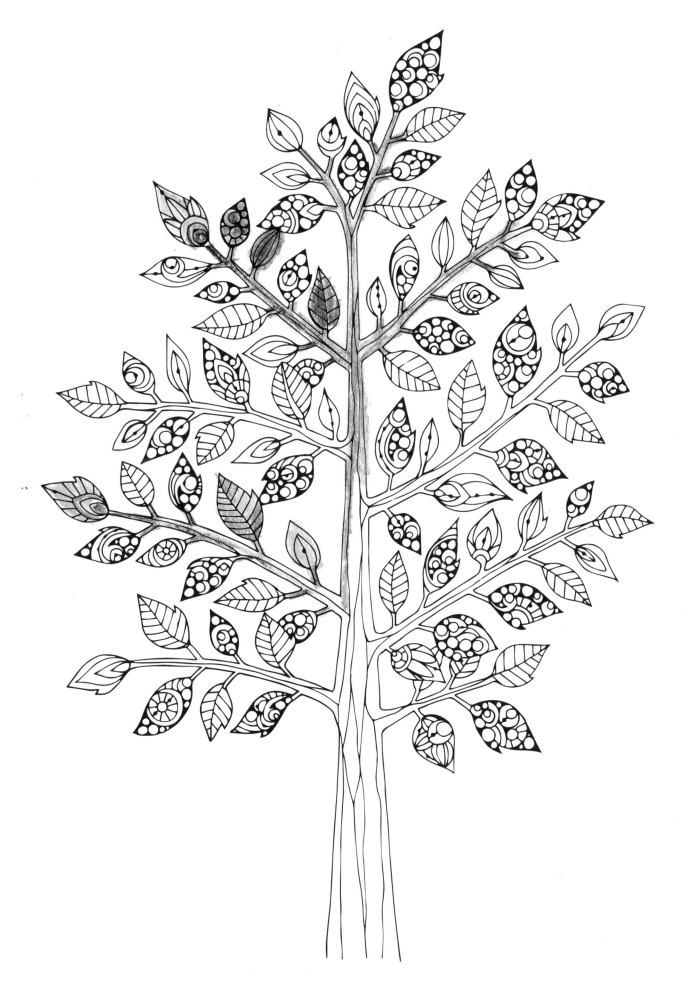

I took a walk in the woods and came
out taller than the trees.

—Henry David Thoreau

Apollonia

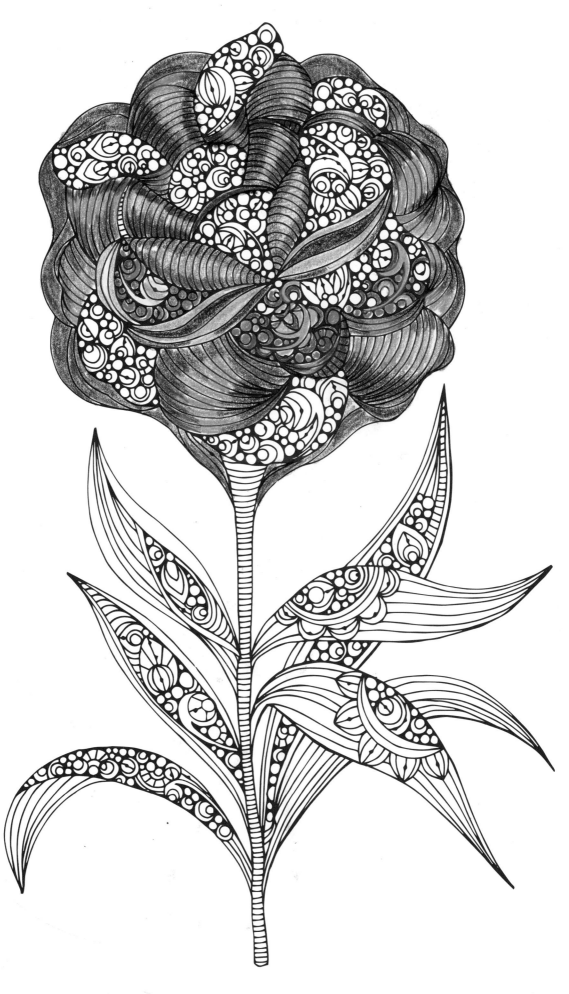

A seed hidden in the heart of an apple
is an orchard invisible.

—Welsh proverb

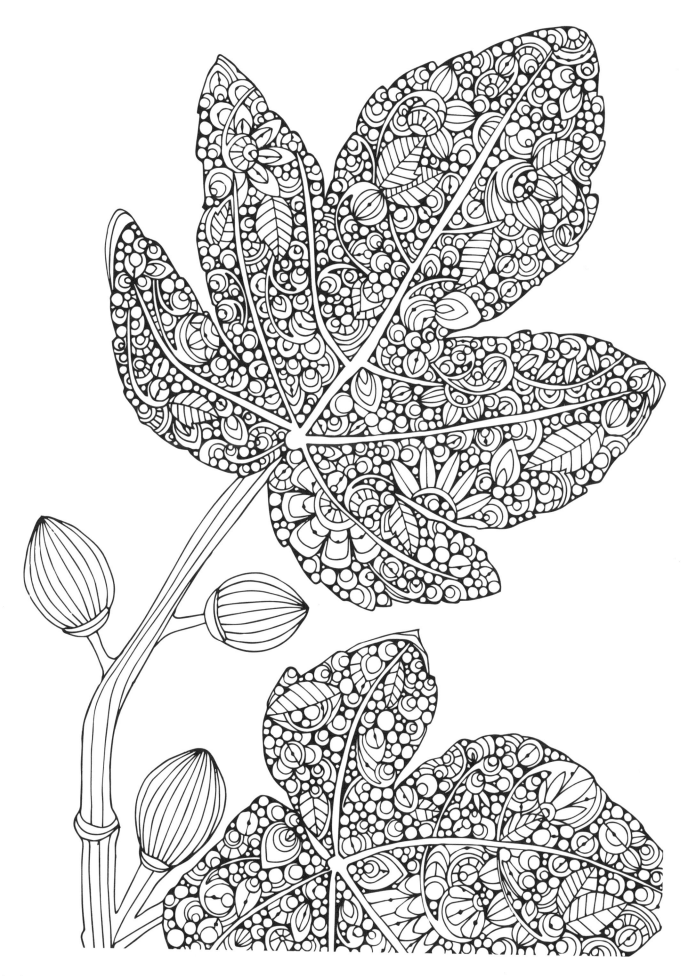

Good timber does not grow with ease:
the stronger wind, the stronger trees

—Douglas Malloch, *Good Timber*

Chios

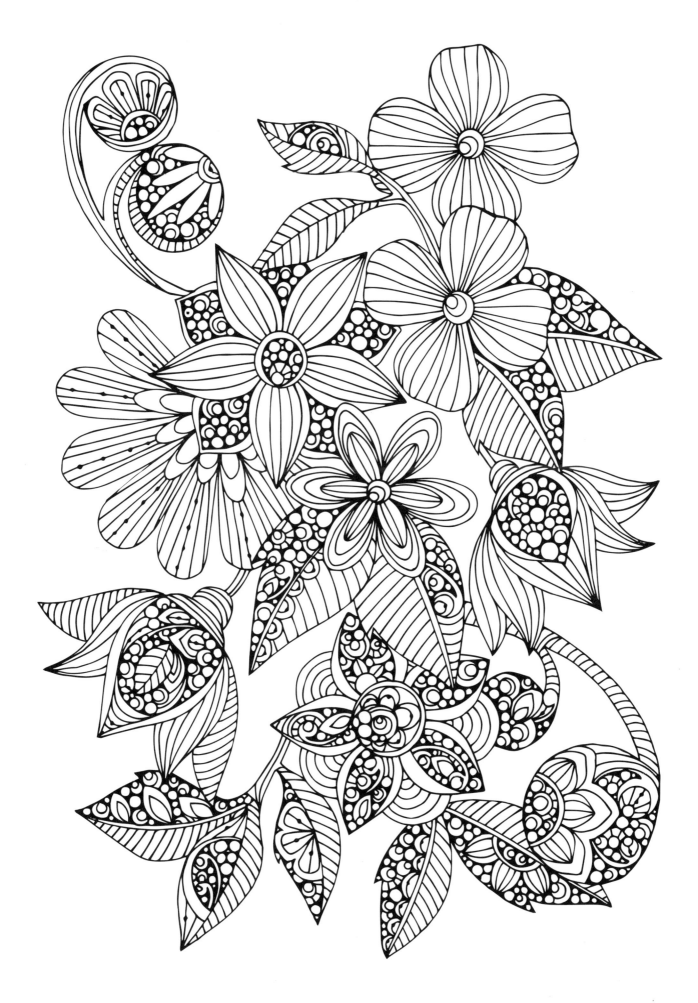

Raise your words, not your voice. It is rain that grows flowers, not thunder.

—Rumi

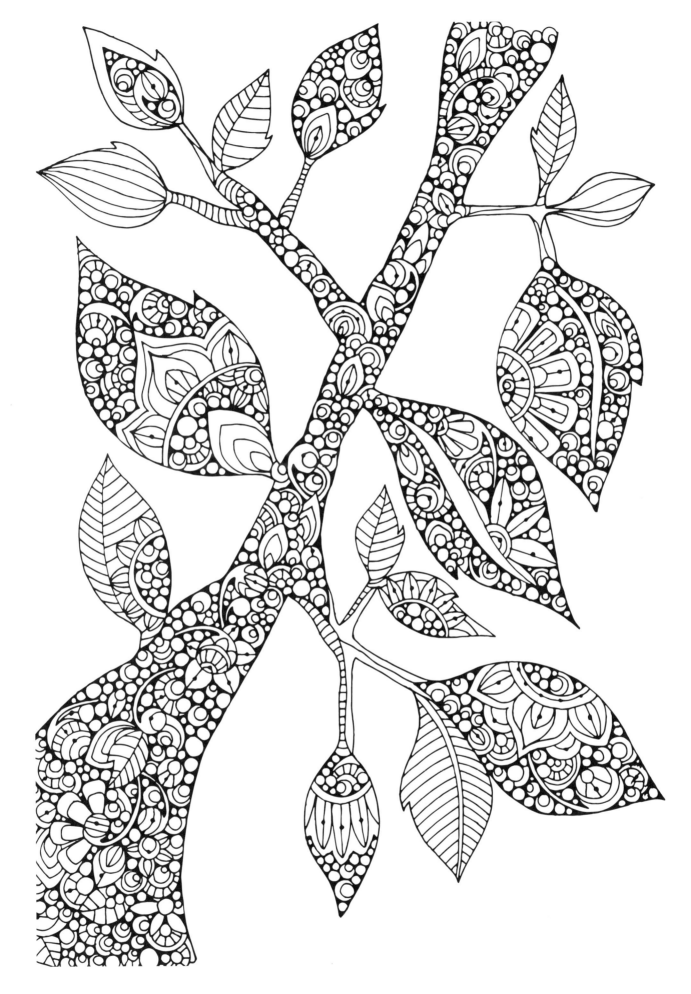

There is no Wi-Fi in the forest, but I promise
you will find a better connection.

—Unknown

Cyrene

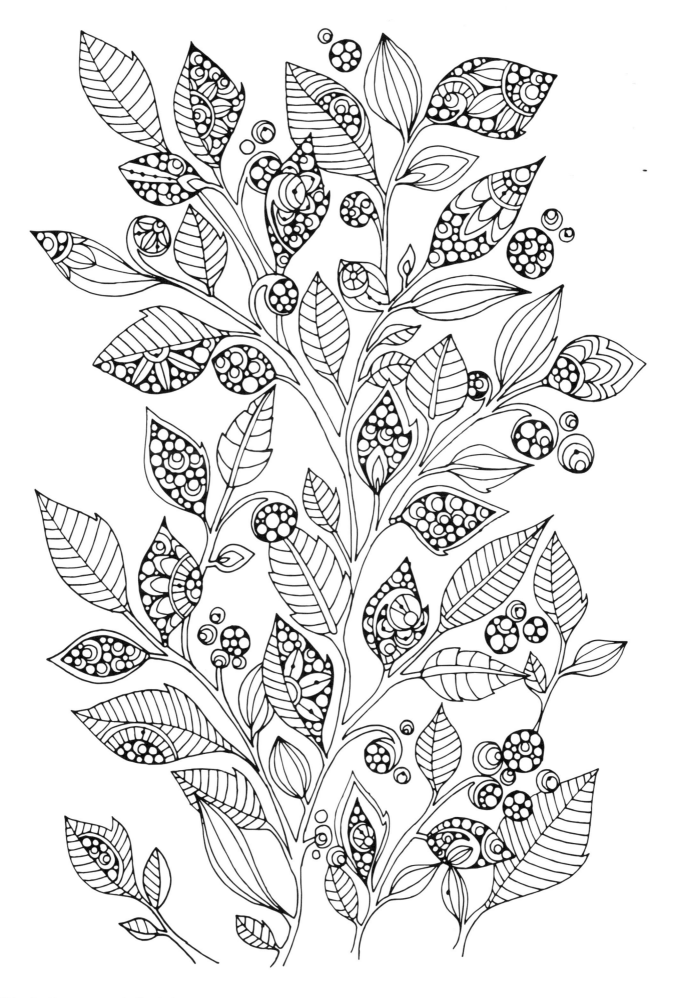

Life is full of endless possibilities.
Explore your world.

—Lailah Gity Akita

Delos

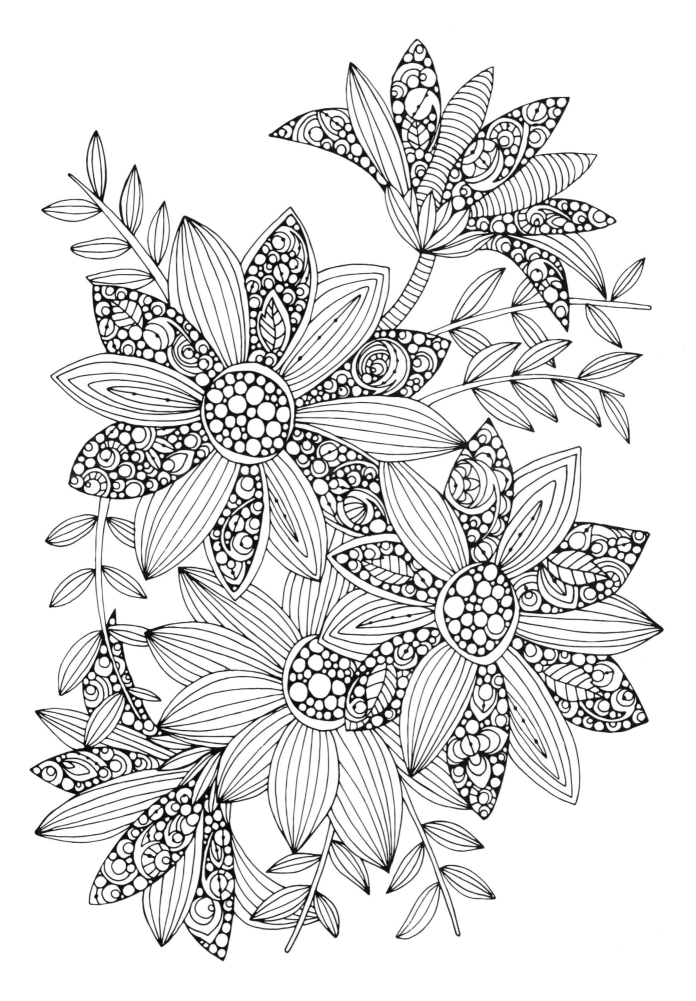

Your head is a living forest full of songbirds.

—e. e. cummings

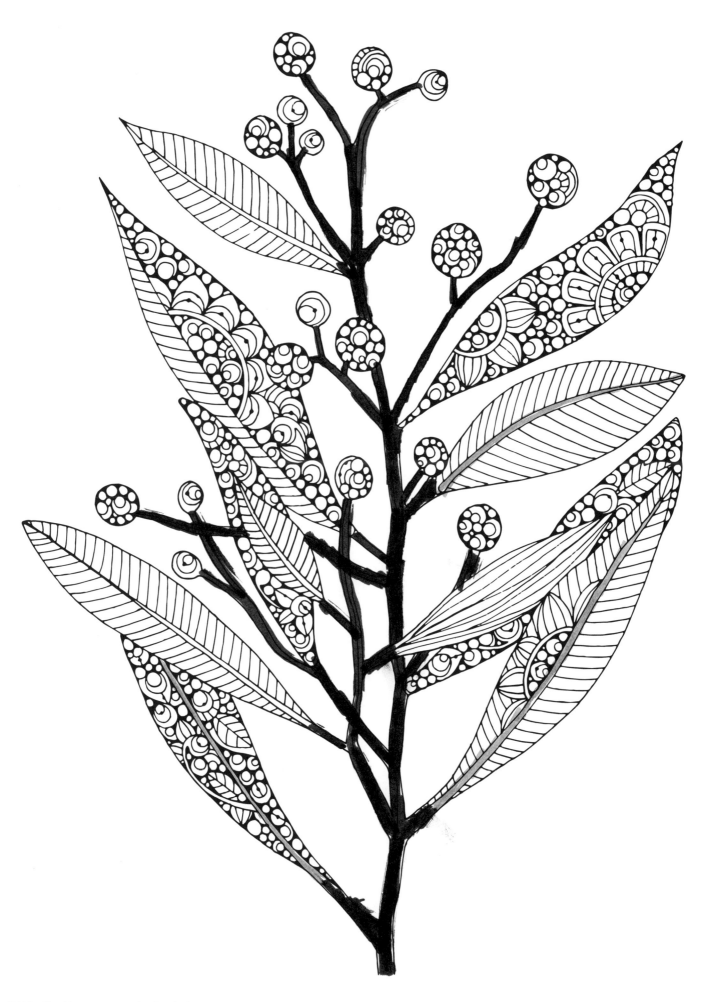

To be yourself in a world that is constantly trying to make you something else is the greatest accomplishment.

—Ralph Waldo Emerson

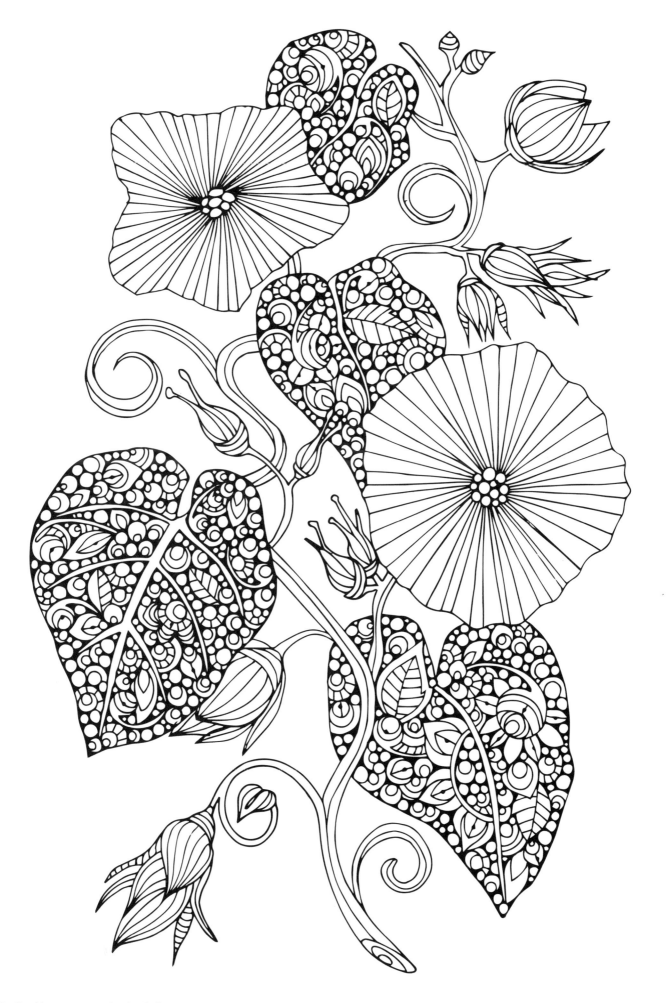

On earth there is no heaven,
but there are pieces of it.

—Jules Renard

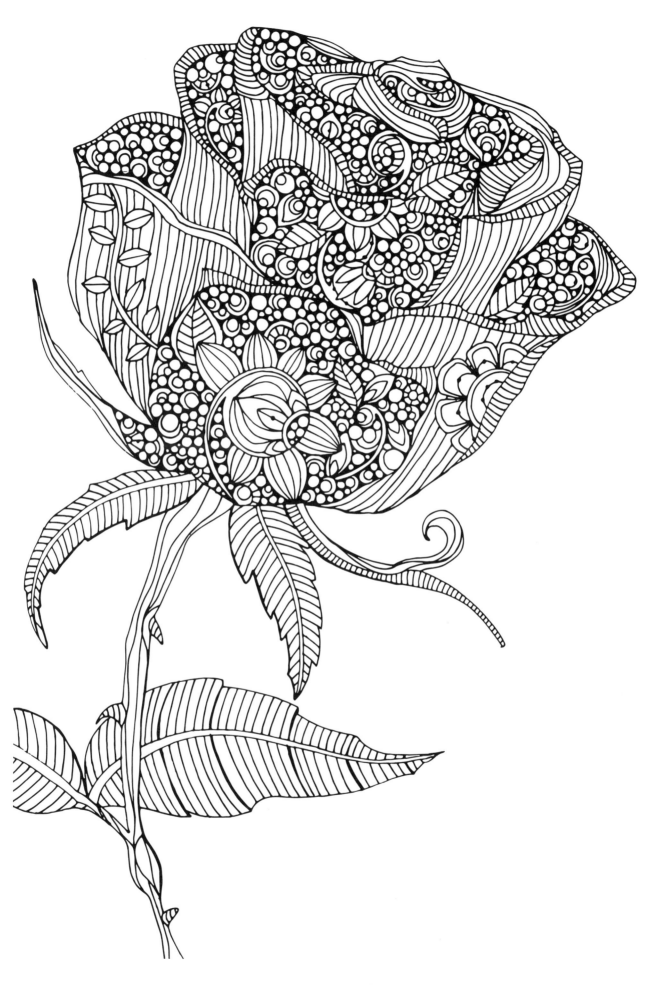

If I had a single flower for every time I think of you, I could walk forever in my garden.

—Claudia Grandi

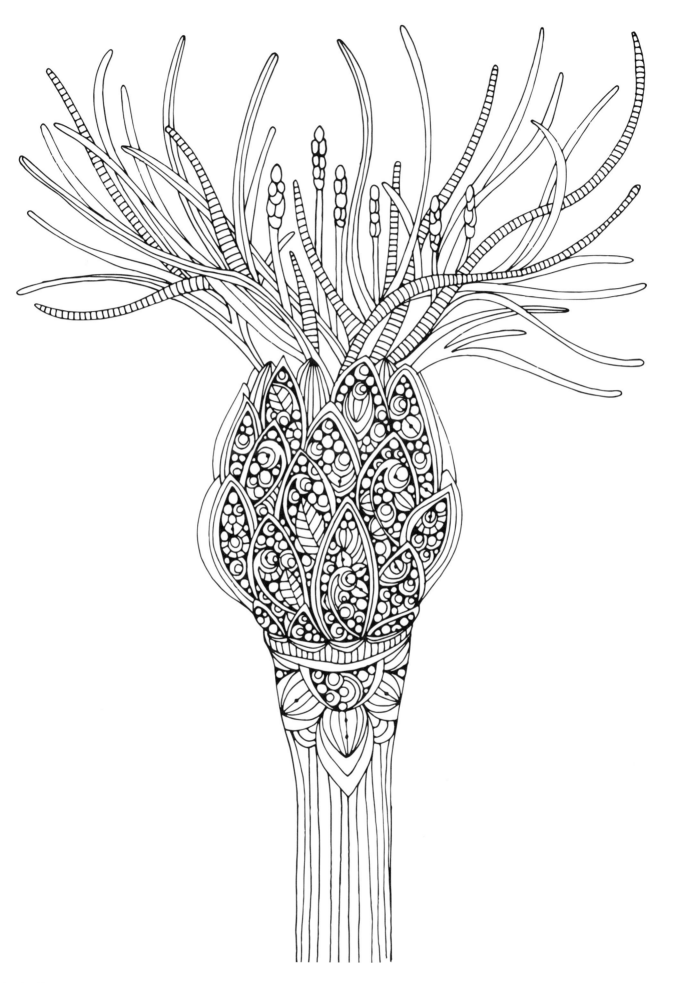

A new day will dawn for those who stand long, and the forests will echo with laughter.

—Led Zeppelin, *Stairway to Heaven*

Kios

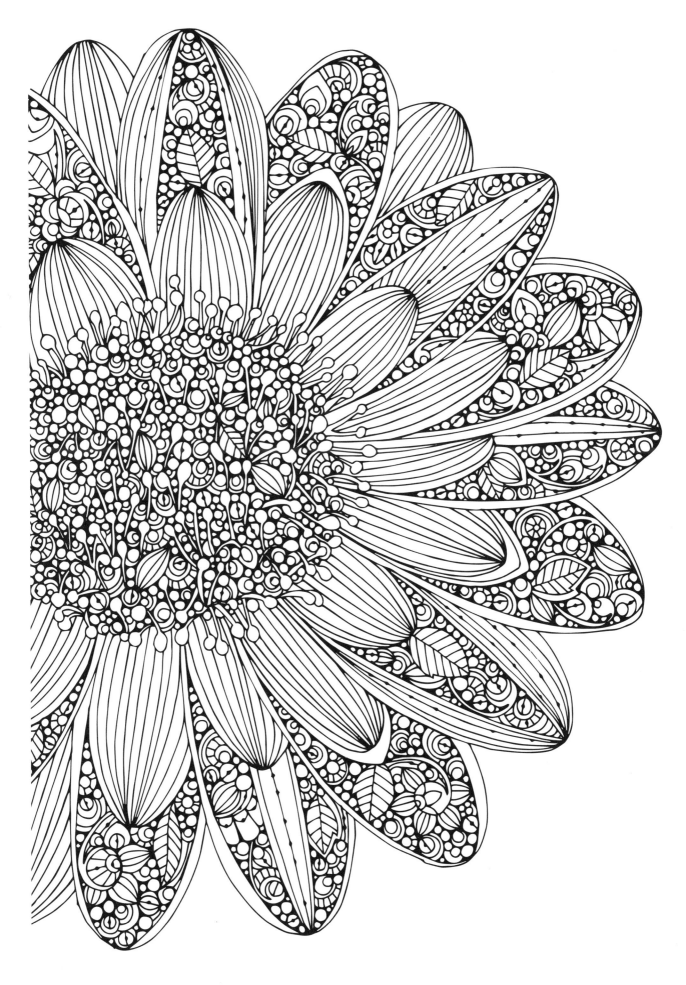

The earth is what we all have in common.

—Wendell Berry

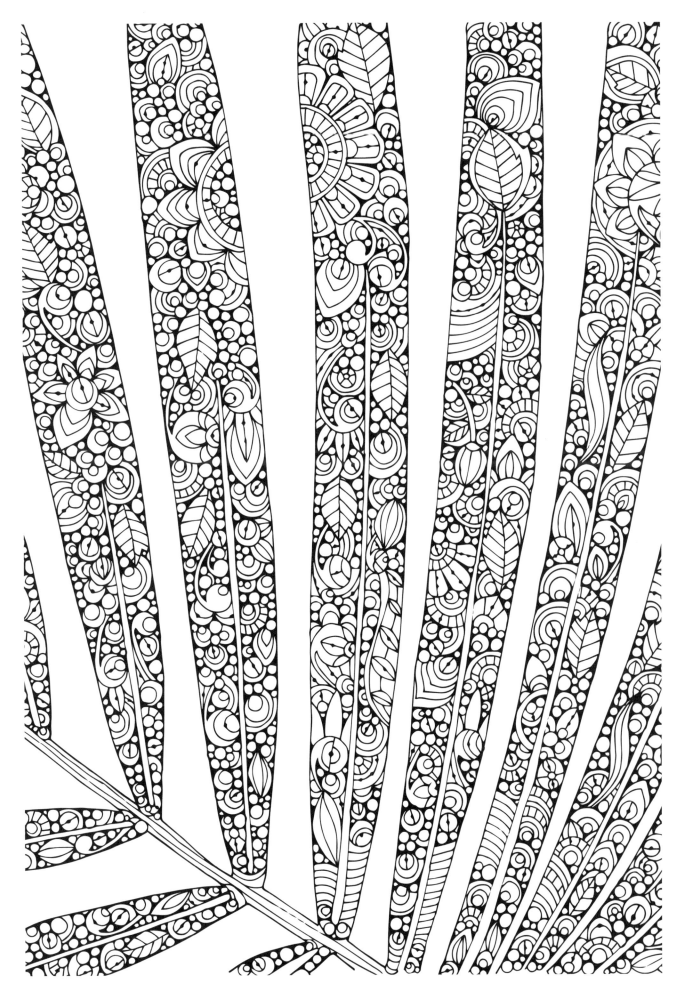

And above all, watch with glittering eyes
the whole world around you, because the
greatest secrets are always hidden in
the most unlikely places.

—Roald Dahl, *The Minpins*

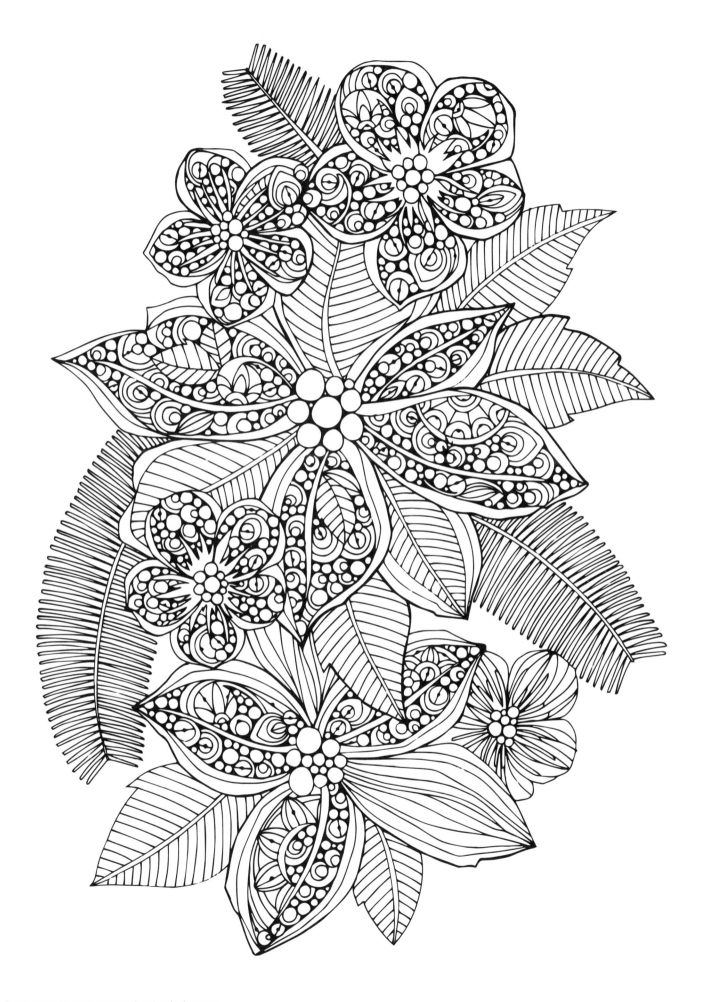

Looking at beauty in the world is the
first step of purifying the mind.

—Amit Ray

Minos

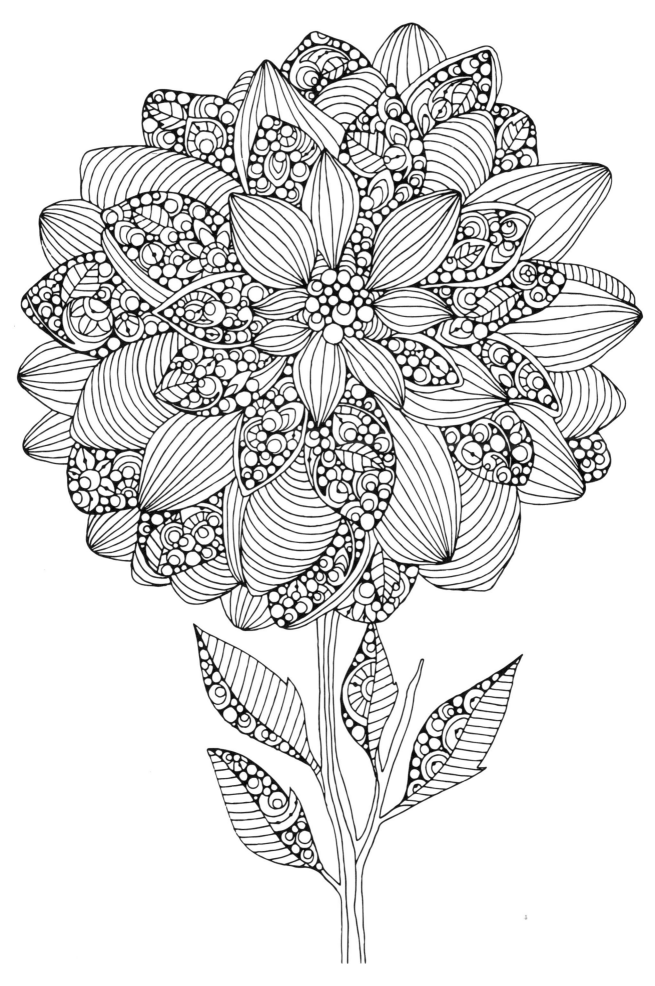

The goal of life is to make your heartbeat
match the beat of the universe, to match
your nature with Nature.

—Joseph Campbell

Mykonos

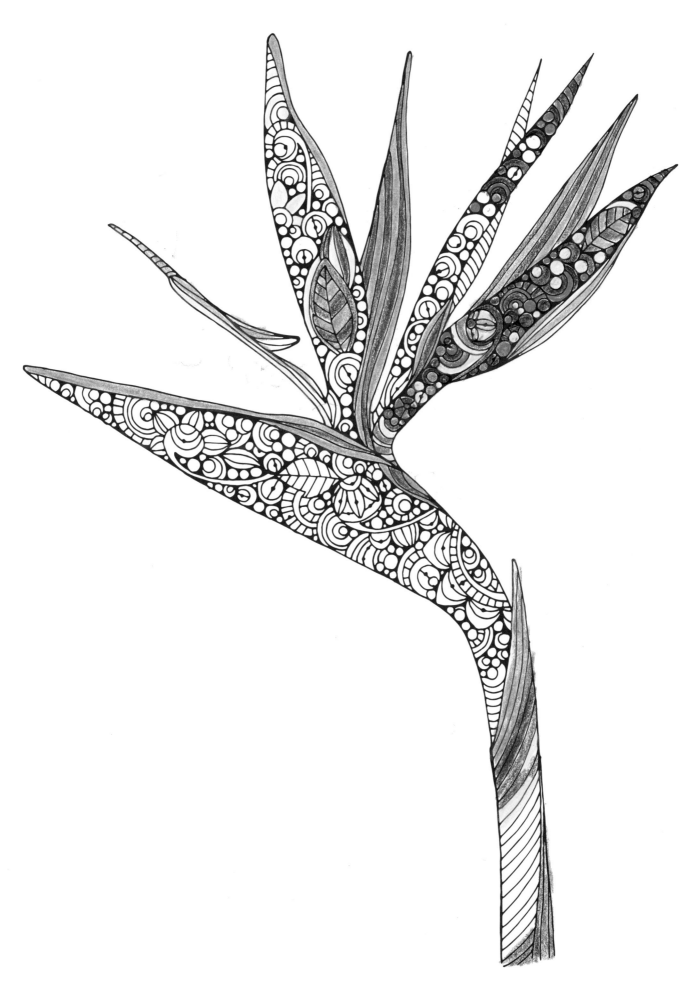

The earth has music for those who listen.

—George Santayana

Mytilene

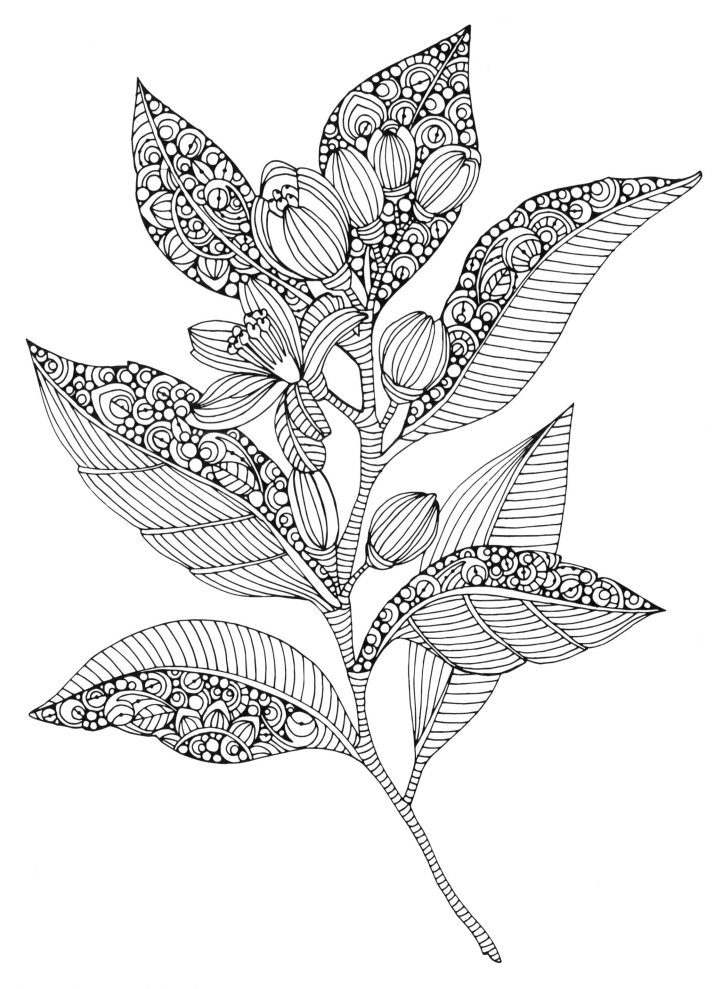

Wherever you go, no matter what the
weather, always bring your own sunshine.

—Anthony J. D'Angelo

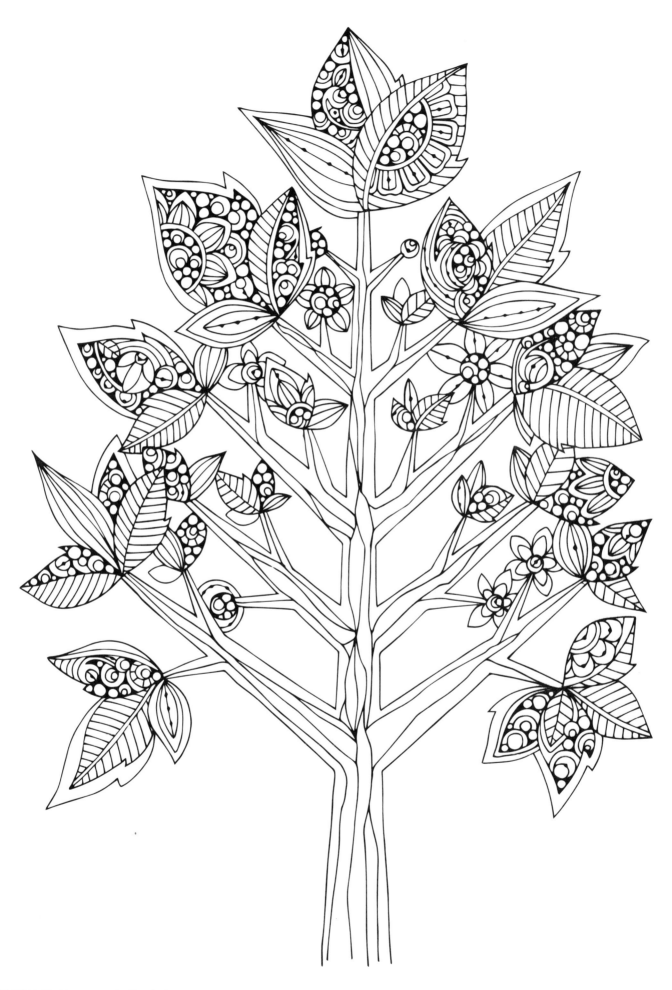

Let's take our hearts for a walk in the woods
and listen to the magic whispers of old trees.

—Unknown

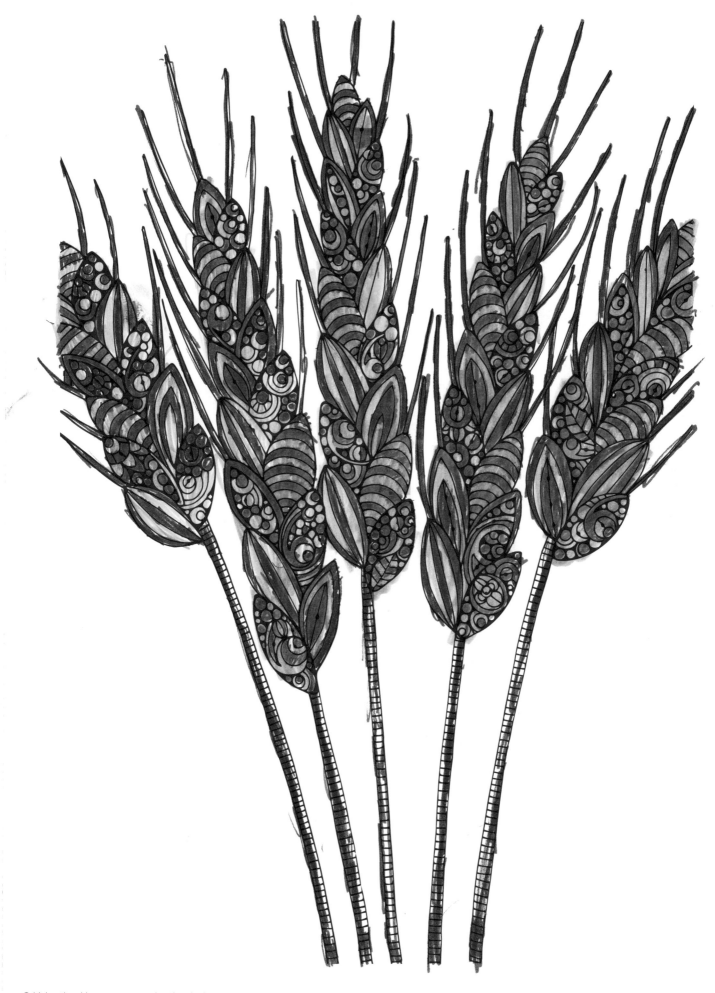

For my part I know nothing with any certainty,
but the sight of the stars makes me dream.

—Vincent van Gogh

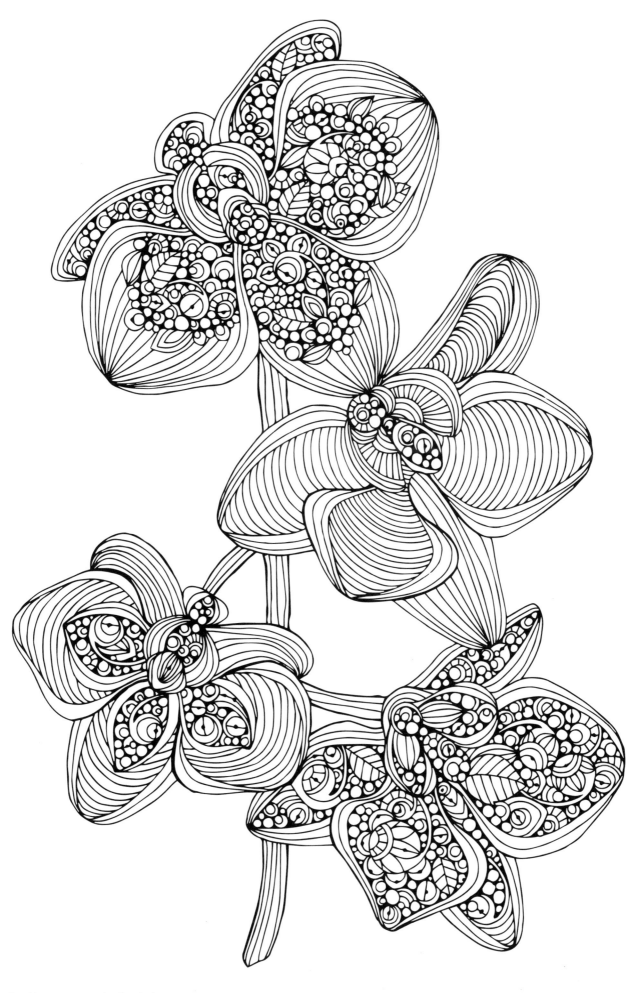

Nature does not hurry, yet everything
is accomplished.

—Lao Tzu

Pylos

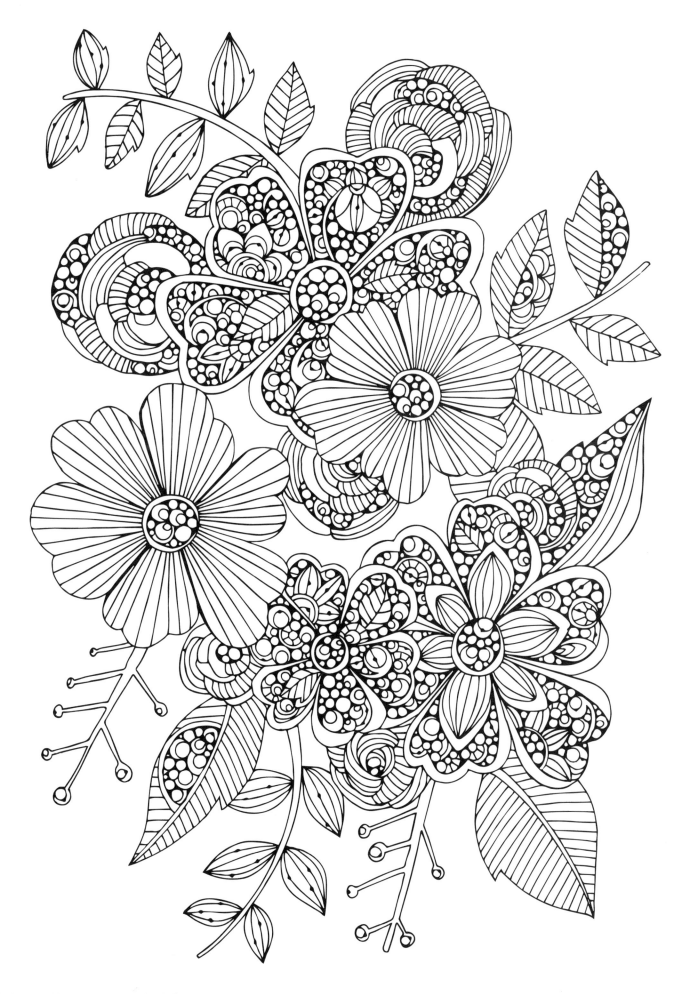

I felt my lungs inflate with the onrush of
scenery—air, mountains, trees, people.
I thought, "This is what it is to be happy."

—Sylvia Plath, *The Bell Jar*

Rhodes

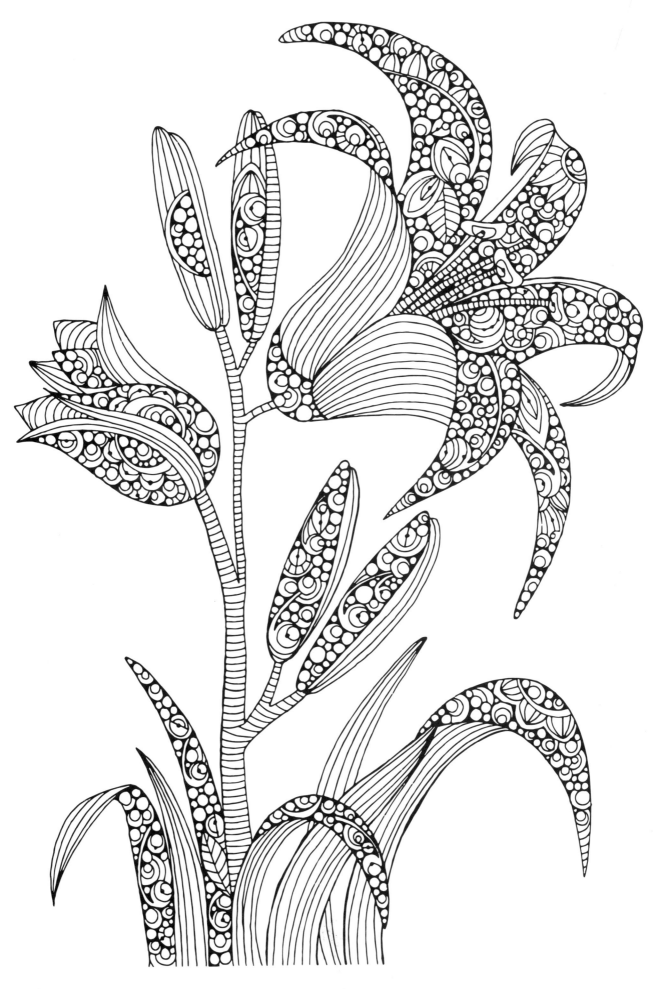

There is a pleasure in the pathless woods,
There is a rapture on the lonely shore,
There is society where none intrudes,
By the deep Sea, and music in its roar:
I love not Man the less, but Nature more.

—George Gordon Byron, *Childe Harold's Pilgrimage*

Samos

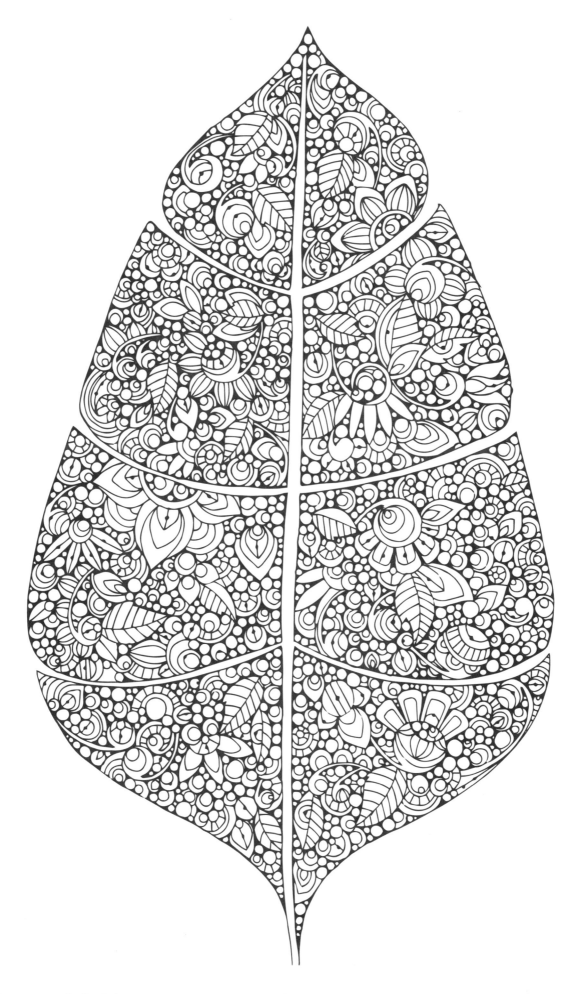

Climb the mountains and get their good
tidings. Nature's peace will flow into you
as sunshine flows into trees.

—John Muir, *The Mountains of California*

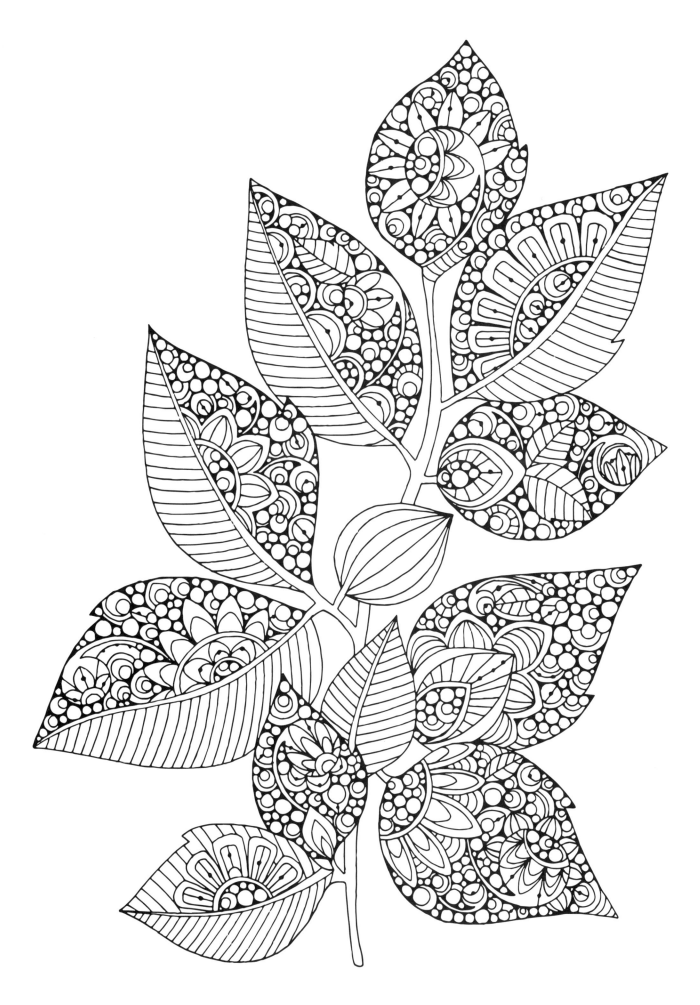

Nature is not a place to visit. It is home.

—Gary Snyder

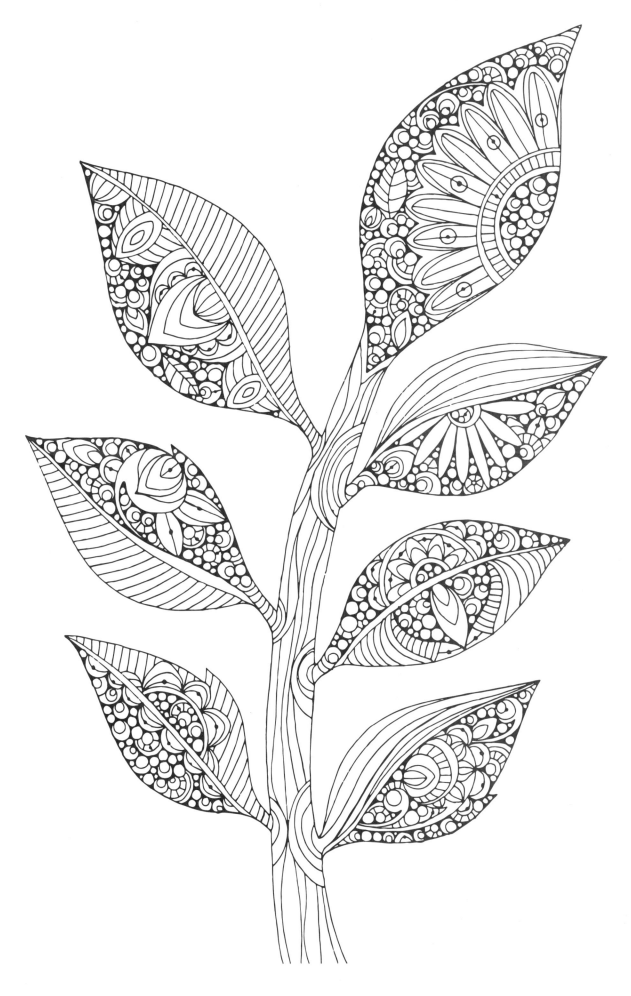

We stood
steady as the stars in the wood
so happy-hearted

—Ben Howard, *Old Pine*

Zakros